Catnip

A Love Story

Catnip

A Love Story

Michael Korda

The Countryman Press
A division of W. W. Norton & Company
Independent Publishers Since 1923

For information about permission to reproduce selections from this book,
write to Permissions, The Countryman Press, 500 Fifth Avenue, New York, NY 10110

For information about special discounts for bulk purchases, please contact
W. W. Norton Special Sales at specialsales@wwnorton.com or 800-233-4830

Manufacturing by QuadGraphics, Fairfield
Book design by Nick Caruso Design
Production manager: Devon Zahn

The Countryman Press
www.countrymanpress.com

A division of W. W. Norton & Company, Inc.
500 Fifth Avenue, New York, NY 10110
www.wwnorton.com

978-1-68268-157-2

10 9 8 7 6 5 4 3 2 1

Contents

Introduction

I have been drawing most of my life, doodling away industriously when I was supposed to be listening, covering everything in front of me—schoolbooks, notebooks, telephone pads, agendas for business meetings, paper place mats—with drawings. Far from being praised for my skill as a draftsman, however, I was mostly criticized or punished for wasting my time doing drawings and not paying attention.

When I was a child I drew characters from my favorite nursery rhymes and children's books. By the time I was in school, I drew airplanes, which fascinated me for years until I was drafted into the Royal Air Force and got my fill of them. Then I finally switched to horses, because they came to play a large part in my life. My

wife, Margaret, and I met while riding on the bridle paths in New York City's Central Park. I quickly became quite proficient at drawing horses, but since Margaret was first and foremost a cat lover, I added cats to my repertoire for birthday cards and anniversaries. Sometimes I even managed to combine the two, which isn't easy, given the difference in scale.

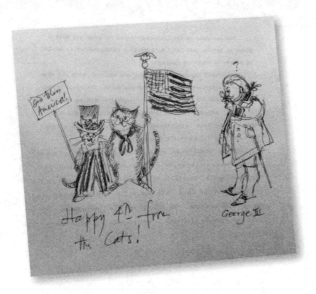

God Bless America!

Happy 4th from the Cats!

George III

In the summer of 2016, a few months after Margaret was diagnosed with a malignant brain tumor, I started drawing a cat cartoon every day in the tack room of our barn, to take her mind off what was happening to her, and, if possible, to give her something to laugh or at least smile about. It had been from the beginning a significant part of our life together to ride every morning, and afterward we always had a cup of Dunkin' Donuts coffee in the tack room—medium skim-milk cappuccino for me, small French vanilla with two creams and

two sugars for Margaret—while we cleaned our boots and enjoyed the air conditioning or the warmth, depending on the season. The tack room was Margaret's domain, the center of what she did, and who she was.

The first few drawings came easily enough, but as the days went by I began to set a few rules in my mind about them. The first was that I would only use the things

that were on hand in the tack room to work with: a couple of ballpoint pens and Magic Markers, and pages from discarded manuscripts of my books, scrap paper basically, on the blank side of which Margaret made notes

to herself or wrote down telephone numbers. Bringing fancy drawing paper or proper pens and pencils to the tack room seemed contradictory to the whole spirit of the thing, which was supposed to be spontaneous, improvised and fun. For the same reason, I tried to do each drawing within five minutes, if possible three—if it took too long to do I feared they would lose the element of surprise, and would eventually become a chore. Some days I skipped altogether, either because we were in New York City for the day, or because I was sick, or because Margaret had to be taken to the hospital for radiation or therapy.

Some mornings I got my inspiration from *The New York Times* or the *Poughkeepsie Journal*, each of which was usually in the tack room next to the scrap paper, other days from some incident around the farm, still others I had to stare at a blank sheet of paper waiting for some idea to come to mind as I sipped my coffee. Many of the drawings revolve around regular events in Dutchess County, New York, where we live. The annual Dutchess County Fair in Rhinebeck is one of them, Millbrook Farmers Market another, Pleasant Valley Day, in our hometown, still another. Some of them reflect the

The cats try out "happy hour" at The Public House Pleasant Valley

weather in our part of the country—winter brings big snow storms, and with them the longing of everyone who can afford it to get away to the south, lie in the sun and read about the snow in the newspaper while sipping a daiquiri by the pool; summer brings heat, humidity and bugs. Others were inspired by big events like the marathon or the presidential campaign (the cats were

not early supporters of Donald Trump). Every once in a while I included a horse, particularly Monty, my favorite among our four horses, perhaps because I found them easier to draw—horses have three pronounced gaits: walk, trot and canter; cats either sleep, slouch along or run like hell if they think they are in danger.

Once I had finished a drawing, I photographed it with my cell phone and emailed it to Margaret. Far from imagining that they might one day be published, I made no effort to save the originals and was not even aware

that Margaret was forwarding them to a long list of her friends until one of them mentioned over dinner that she had particularly liked yesterday's drawing. This caused me some surprise. If I had known they were going out to a dozen or more people every day I might have drawn them more carefully, but that too would probably have spoiled the spontaneity. I decided not to ask who was

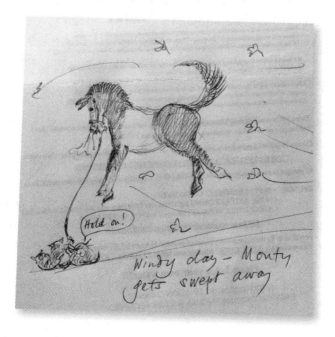

Windy day – Monty gets swept away

receiving them, since the object was to amuse Margaret. If she wanted to show them to her friends it was no business of mine, and it was not until later that I realized how proud she was of me, or how much she enjoyed sharing them.

Animals are on the whole easier to draw than people—they can't complain that you've made them look too fat or silly for one thing—so human figures don't often appear in these drawings, although I have tried to respect the dignity of the cats. Our cats dislike being made fun of, and when they make a mistake like leaping for a tabletop and missing it, they have an altogether human way of pretending that the incident never happened. My cast of cat characters changed slightly with time. George, a large orange cat who was Margaret's favorite, and unlike most cats was something of a clown, died early on, leaving only Ruby, the shyest of our cats, and Kit Kat, the boldest, in the house, while Tiz Whiz lived in the tack room, with an occasional cat visitor from the woods since she had a plastic pet door. They were all adopted cats which had come in from the woods, nervously nibbled at a plate of food and eventually stayed—to paraphrase Caesar, they came, they saw, they conquered.

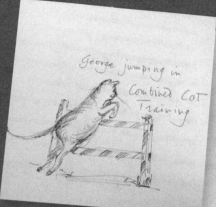

George jumping in Combined Cat Training

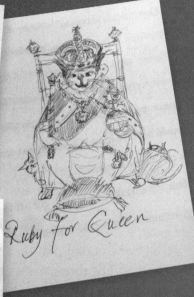

Ruby for Queen

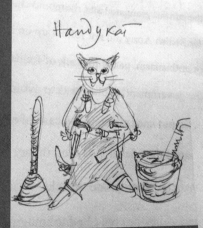

Handy Kat

Wake me when it's Tom and Jerry!

CATS AT THE MOVIES

I was not a born cat person myself, and my first major exposure to cats on a day-to-day basis was with Margaret's cat Irving, a marmalade orange cat who resented my presence. I did not take that personally, Irving had disliked Margaret's previous husband, and I think he would have felt the same about any man who came between himself and Margaret. In his younger days Irving had been something of a traveler, since Margaret took him with her everywhere she went when she was modelling. He went by train to the Okefenokee Swamp, by plane to the Beverly Wilshire Hotel (where he damaged the drapes of the suite so badly that Margaret was asked not to bring him back again) and to Mexico, as well as by taxi to movies and the theater. By the time Margaret and I were living together, Irving's wanderlust, if he had ever felt it, was over, and all he wanted was to stay put. He made his feeling on the subject known by throwing up the minute he got into the car for trips back and forth to our house in the country, and by continuing to throw up and drool all the way up or down the Sawmill and Taconic parkways. At home he placed himself firmly on the bed between myself and Margaret, like a furry, four-legged chaperone. In his favor, he did not bite or

scratch, violence was not in his nature, but he regarded me suspiciously as a rival for Margaret's affection.

Since Irving's time, there had been many cats in our life, most of them strays adopted by Margaret, some of them with winning ways, some not, and I became accustomed to them enough to co-write a book about them, *Cat People*, with Margaret—even though few things are more stressful in a marriage than collaborating on a book. I came to agree with Mark Twain's comment,

"When a man loves cats, I am his friend and comrade, without further introduction." (Twain appears to have had four cats, or at least four who were willing to be photographed together.) I also came to understand why Francis Ford Coppola decided to begin *The Godfather* with a scene in which the ruthless Mafia leader Don Corleone is stroking a cat seated upon his lap—it makes the don seem to the viewer right at the start of the movie like a sympathetic and even a gentle person with whom the audience can relate. In June 1940, at the beginning of the Battle of Britain, John Colville, the

KIT KAT JUST
INTERVIEWED BY
PRESIDEN-ELECT
FOR SECRETARY
OF CATS

Prime Minister's Assistant Private Secretary, described Winston Churchill "lying in bed, in a red dressing-gown, smoking a cigar and dictating," with Nelson, the Admiralty cat, "sprawled at the foot of the bed, and every now and then Winston would gaze at [him] affectionately and say 'Cat, darling.'" To the irritation of admirals, generals and air marshals, Churchill was apt to ask Nelson what he thought of whatever was under discussion, while feeding the cat leftover bits of bacon and toast from his breakfast tray. Mark Twain was surely on to something—it is hard to imagine any of history's great

despots, Hitler, Mao or Stalin for example, being a cat lover. Cats tend to bring out the best in people if it is there in the first place, they are not greedy for attention or slavishly loyal like dogs, and whereas a dog will accept a human as leader of the pack, cats see themselves as the boss and are not easily fobbed off with an occasional pat on the head or a quick scratch behind the ear. Uncritical admiration for its owner is not hardwired into a cat, although it has to be said that Margaret's cats treated her with affection, but as an equal, not in the

subservient role of "a pet." Certainly, cats do not seek praise or practice obedience or do tricks on command.

The cats in this book, like the real ones on which they are based, are therefore above that sort of thing. So far as is possible they try to live life on their own terms, with a sense of independence unusual for a "domestic animal"—for cats, however cossetted, are not "domesticated." All Margaret's cats came in from out of the wilds where they had been living, admittedly attracted by a plate of food and the promise of warmth, but always retaining their ability to go back into the wild and survive by their own skill at hunting. Indeed, Kit Kat, who went in and out of the house on her own will until old age slowed her down, was a skilled hunter of mice, small birds and chipmunks, and if she was in the mood would carefully place the lifeless little body in one of the sneakers or Wellington boots I tend to leave on the porch outside the front door. That always saddened and irritated me—I like songbirds and go to a lot of trouble to feed them—but Margaret, although a greater animal lover than I am, was more philosophical about it. The nature of birds is to sing, she would say, the nature of cats is to kill them, you have to accept animals as they

are. That did not always console me—I found it upsetting whenever Kit Kat managed to kill a cardinal since I love the cheerful flash of bright scarlet as they fly past the kitchen windows—but we had been on safari in East Africa often enough for me to know that Margaret was right. Whatever size they happen to be, cats are cats.

Of course by cartooning cats, one lends human feelings and thoughts to them, but anthropomorphizing animals is one of the staples of humor. It was

the foundation of Walt Disney's enormous success after all to give a mouse or a duck human feelings, so why not a cat? Indeed, Felix the Cat preceded Mickey Mouse on screen by almost ten years, setting the course for Disney. Anyway, the cat cartoons made Margaret laugh, even on those days when there wasn't

much else to laugh about, just as the presence of the real cats gave her a kind of comfort. Tiz Whiz, in the tack room (she is named after a popular horse feed) was the most affectionate; while I was doing the drawing Tiz Whiz would leap down from one of the saddles on the saddle rack where she had been sleeping and rub herself against Margaret's riding breeches to signify that she was ready for her daily brush. It was the biggest moment of Tiz Whiz's day, and the brushing couldn't

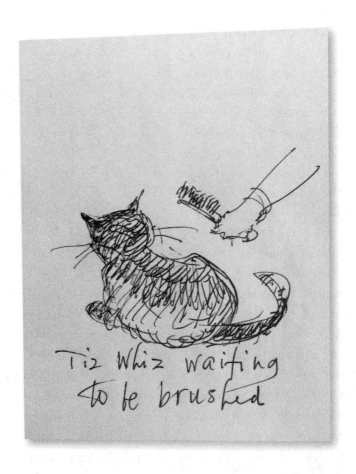

Tiz Whiz waiting
to be brushed

go on long enough to satisfy her. Kit Kat, on the other hand, hated to be brushed but liked to sleep right up against Margaret, digging her claws into the bedspread to signify her pleasure. Ruby spent most of her time in the linen closet (or under the bed when there was vacuuming going on), but loved being present in the morning when Margaret put her makeup on, rubbing against her and trying to share the moment. It was not their affection that Margaret craved, she needed their presence, they were a part of her world, their schedule, when they got brushed, when they got fed, gave order to Margaret's day, as did the horses. Even when she became really, *really* sick, in hospital, after the surgeries and the radiation had taken their toll, her first question to me was, "How are the cats?"

It pleased her to know that the cats were doing well, both on paper and in real life. And although cats do not as a rule pine over the absence of their owner—does anybody, really, *own* a cat?—the behavior of the cats was subdued when Margaret was away, and pleased when she returned. Even the reclusive Ruby would appear from wherever she was hiding to greet her and make a discreet, affectionate purr. They seemed to have an

Kit Kat on The cell phone

instinct for when some-body needs comforting, and towards the end of Margaret's life—she wanted to die in her own bedroom, in her own bed—the cats took turns lying beside her, what-ever else was going on, making their presence known by their warmth and a low, soothing purr. Ruby, who hides from any stranger, braved the presence of the 24/7 caregiver or the home hospice nurse to keep a kind of vigil on Margaret. How cats know someone is dying, I have no idea, but they do, I can testify to that.

In any case, these cat cartoons represent over a year of life, over a year of love, an attempt to bring an almost daily dose of humor to a situation that was increasingly dark, and a chance every day to make Margaret smile. If they make others smile, I will be happy, for who doesn't need a bit of humor in their life? It would have pleased Margaret, perhaps it will even please the cats.

Ruby faces the storm

Cats of Character

STARE-OFF BETWEEN
TIZ WHIZ AND KIT KAT
OUTSIDE THE TACK ROOM

Kit Kat hunting for chipmunks

Yah, yah, yah!

chipmunk

Kit Kat joins the R.A.F.

KIT KAT: A female patched tabby named after the well-known chocolate bar (which was one of Margaret's favorites). Kit Kat is an indoor-outdoor cat, and a relentless killer of small birds and chipmunks, who likes to place the victim's body in one of my shoes on the porch as a surprise for him. She can be affectionate when in the mood, but if she feels underappreciated she can give a razor-sharp slash with her claw. I keep a special stock of Band-Aids for the finger and iodine in the kitchen for first aid (Kit Kat never attacked Margaret). She does not like men. Her favorite place is curled up next to Margaret on the bed, or on the sofa while Margaret watched TV. For reasons best known to herself, Kit Kat will only drink from the running faucet in the kitchen.

Sunday morning – Kit Kat reads the paper

GEORGE: A large orange male, pushy, a bully, something of a clown, who likes to hold the high ground, the top of the refrigerator, for example. George is a strictly indoor cat and he and Kit Kat are rivals for certain spots, like a patch of warm sunlight on the dining room floor. Although George is much bigger than Kit-Kat, she always wins in the end, since she has a mean streak and he does not. George is the only cat we ever bought,

George meets a pig

as opposed to their turning up at the house out of the woods, since Margaret particularly loved orange cats, and saw him in the weekly ad in the *Poughkeepsie Journal* from the Ulster County ASPCA in Kingston.

RUBY: Also known as "Ruby 9/11" because she appeared at our annex barn on September 11. Ruby is now a large tabby female but was then a very small kitten when Margaret saw her as she rode past, dismounted, gathered the kitten up in her arms, and rode home with her, where Ruby has stayed ever since. Ruby is the gentlest and most caring of cats, for months she nursed and comforted Margaret's beloved Mr. McT while he was dying, embracing him with her paws and licking his face, the Florence Nightingale of cats. It wasn't so much that there was any love lost between her and Mr. McT, he was an unforgiving despot, undisputed el jefe of our cats, but she felt sorry for him as he began to decline. Illness, feline or human, brings out the best in Ruby, she is the equivalent of a living, breathing hot water bottle if you're ill. On the other hand, she flees noise and strangers. Noise of any kind drives her under the bed for hours, strangers drive her into the linen cupboard, where she hides for days at a time behind the towels, emerging only for meals and cautious trips to the litter box. She also dislikes vacuum cleaners, thunder and July 4th fireworks.

TIZ WHIZ: Tiz Whiz has her own domain, she is "the barn cat." She does not come into the house, her home is the tack room, and her job is to deal with mice in the barn, which she does with ruthless efficiency. Otherwise, she rests up for the day on a folded saddle pad. The high point of her day is morning coffee in the tack room, when she gets brushed with a Mason-Pearson hairbrush, and takes a bit of cream cheese from a Dunkin' Donut toasted bagel when offered to her on a fingertip (she does not like flavored cream cheese, just the straight kind). Because the tack room has a pet door so she can go in and out, Tiz Whiz has occasional nocturnal visitors, Lucky (a large gray and white cat) being the latest one. Her visitors do not come

Tiz Whiz gets a manicure

Let's be friends!

Hi!

Tiz Whiz Friend or foe?

calling until after barn check, and invariably leave at first light, and a special plate of cat food is put out for them, usually Friskies, which for some reason Tiz Whiz won't touch. The guest plate is always empty in the morning. Tiz Whiz regards patrolling the barn as her responsibility and takes her job seriously. She is not afraid of the horses, and they know and recognize her and are always very careful where they put their hooves so as not to step on her. In cold weather, she retreats to the hayloft and burrows down in the hay.

MR. MCT: A large black and white cat who turned up out of the woods, sat down on the front porch, walked in when Margaret opened the door and never left. Until his illness, Mr. McT was in his quiet way ruler

Nurse Ruby practices bandaging

of the roost, the feline equivalent of a retired beat cop, big enough and tough enough so that he didn't need to take any s—t from anyone. He never resorted to fighting, scratching or raising his voice, he just had to open one sleepy eye to restore order. He adored Margaret but was indifferent to any other human being. He regarded himself as her protector and usually spent the night lying on the mat inside the front door to guard against burglars, coming upstairs at intervals to rub against her face or hand and let her know that everything was OK, then going back downstairs to resume his job. The lady cats all adored him, but he was indifferent to them, he expected to be adored. He went out occasionally for a leisurely walk around the garden like a cop on the beat, and when he wanted to get back in he would sit outside a window until he caught your attention with a reproachful glare. Eventually cancer struck Mr. McT down, and despite the best of care he sickened, weakened and died, nursed by young Ruby, who never left his side, a love story of sorts.

JFK: An admirer of Tiz Whiz's, JFK was a smooth, graceful and attractive black cat who defied every attempt to bring him indoors. In his presence, Tiz Whiz became positively giddy with desire, hence his name, but she was not his only girlfriend and he would sometimes disappear for days at a time, until somebody would see him sauntering up to the tack room and cry out, "Margaret, JFK is back!" He was handsome, sexy, smart and very much his own cat. At some point he vanished, leaving Tiz Whiz forlorn until the arrival of Lucky.

JFK takes a "selfie"

JFK AND TIZ-WHIZ

JFK dancing

LUCKY: We don't know much about Lucky, he comes and goes, occasionally he can be seen lurking near the barn, waiting for the barn crew to go home so he can saunter into the tack room for his dinner. Tiz Whiz does not seem quite as giddy about him as she was for JFK, but she likes company, and he likes Friskies, so it's the basis for a relationship of sorts.

TIZ WHIZ WATCHES
GRAY AND WHITE VISITOR
EAT HER DINNER

TIZ WHIZ

Tiz Whiz and
new ~~fiend~~ friend in tack
room

MONTY: As the reader may notice, Monty is not a cat. He is a Western Paint Horse, who began his working life as a lowly packhorse on a Montana dude ranch, and has the brand on his right shoulder to prove it. Elfreeda Williams, a noted event rider and shrewd judge of horses from North Carolina, saw him in the line of packhorses, liked the look of him, bought him on the spot, and had him shipped home. She named him Montage, but everybody shortens it to "Monty." Amazingly, his new owner

trained him to become a successful combined training competition horse, which means being able to win in the three different phases of combined training, dressage, cross-country and stadium jumping, which you wouldn't think a simple old country boy who carried a pack on his back could do. Margaret saw him and said to his owner that if she ever wanted to sell him, would she please call her. "Congratulations," Monty's owner in North Carolina wrote when Margaret bought him, "Monty is one of the nicest horses I've ever been privileged to work with." This became true for Margaret as well. Despite his flashy Western colors (big splashes of pure white and bright, almost orange chestnut) and his stocky cow-pony build, Monty took Margaret to #1 at the national novice level, although

Monty reads Peyton a story.

Tiz Whiz offers Pip a treat

dressage judges tend to prefer Thoroughbreds or Dutch Warmbloods to Western horses. Dressage, like figure skating, means not only doing each movement right, but looking right to the judge while doing it, so it was like watching a cowboy performing perfectly as a ballet dancer. Anyway, when Monty retired from competition he became "my" horse, although his heart remained with Margaret. He is the nicest horse in the barn, he doesn't shy, kick, refuse a fence or buck. He is

what horsemen call "an honest horse," and has actually been known to stand still while a cat sits on his broad back, and likes the presence of Tiz Whiz at stressful moments, like a visit from the vet or the farrier. Peyton, the six-year-old daughter of Megan, who helps look after our horses, is in love with Monty and wants to take him home as a pet, but since he weighs almost a thousand pounds and isn't housebroken that probably isn't going to happen anytime soon.

Summer

A Day at The Beach

Café Les Baux, in nearby Millbrook, is our favorite restaurant around here, an oasis of good authentic French cooking in an otherwise desert landscape of pizza and steakhouses, a soothing place which Margaret loved. One of the *patron* Hervé's staples is a dynamite *sôle meunière*, nothing fancy, just a perfect piece of fish sautéed to perfection in good butter. It was a great favorite of Margaret's, and since Hervé's portions are generous, Margaret took to bringing her leftovers back for the cats. Kit Kat, and even that notoriously fussy eater Tiz Whiz, both relished a few pieces of *sôle meunière* added to their dinner.

Whenever we went out to dinner they wrinkled up their noses in anticipation, and were mightily disappointed if we went somewhere else and brought them back any other kind of leftovers. It wasn't just the sole—we bought sole and cooked it for them, but they could tell it wasn't coming from Les Baux; it didn't have that slightly crisp crust and delicious sauce that is just butter, fresh lemon juice, salt, and pepper, but which only a good French cook can get just right. Without Hervé's sauce they had no interest in sole. It's not for nothing that France is famous for her cuisine—it turned out that the cats had a discriminating palate when it came to sole.

If they were to go out to dinner, where else would they go but Les Baux, with nice bottle of Sancerre on ice and napkins tied around each neck, just as if they were in France?

The cats at
Les Baux

one of us isn't a cat?

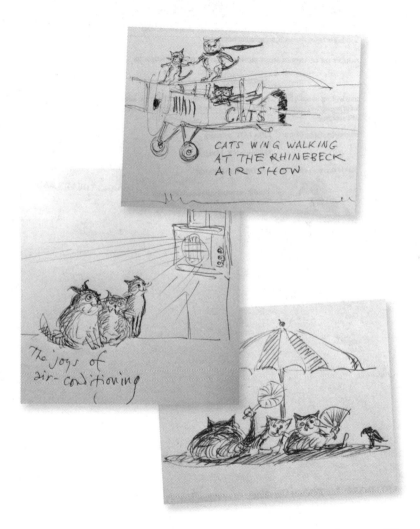

CATS WING WALKING
AT THE RHINEBECK
AIR SHOW

The joys of
air-conditioning

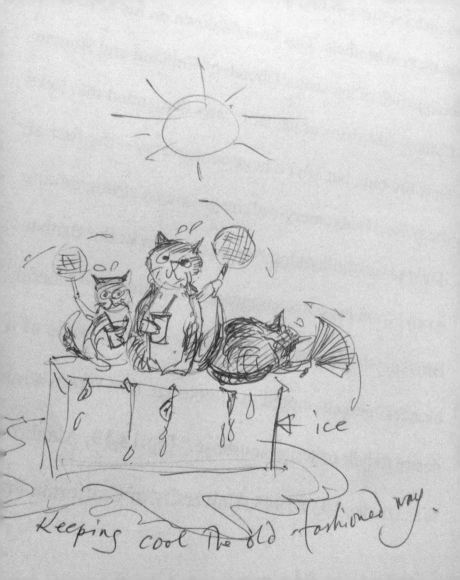

ice

Keeping cool the old fashioned way.

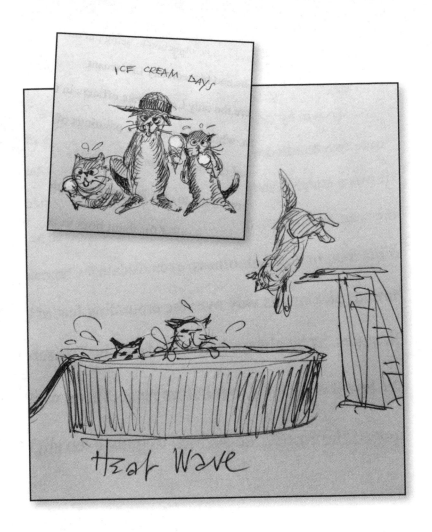

Ruby takes first try at The water park chute.

100°!

Tiz Whiz harvesting tomatoes

picking tomatoes

TOMATO SEASON

HOME GROWN
TOMATOES
$1 A POUND

Kit Kat in Command

CHICKEN WITH PEAS FOR EVERY CAT

KIT-KAT FOR PRESIDENT

A MOUSE IN EVERY POT

Kit Kat is, to be frank about it, a bossy cat, determined to have her own way. Unlike Ruby, she goes in and out. Out involves sitting by the door and giving off piercing cries until somebody appears to open it. In involves the same, only more of it and at a higher pitch, accompanied by appearing at a window and scratching it until somebody comes along to let her in. So that we are not accused of cruelty to animals, in the winter we have a snow porch with a cat door so she can shelter from the elements, and all else failing she can go through the cat door into the heated tack room, where she sulks until somebody appears.

In good weather, she goes out and kills things, or lies in the sun, or takes a long stroll to make sure everything is in order and that songbirds, mice, moles, chipmunks, squirrels and other pests don't present a threat to us—I was about to write "to her owners," but as the saying goes, "Cats don't have an owner, they have staff."

Her ferocity is legendary. Whenever Kit Kat had to visit our vet, Mike Murphy, he got out what he called his "armored gloves" before trying to deal with her; she was a ball of quivering, indignant, slashing rage, with claws as fast as a bullet and as sharp as a razor. It was, needless to say, hopeless to try and give her pills, so the only way to give her medication was to bring her in to the vet, wrap a towel around her head and let Mike give her a shot. Getting her into her box to take her to the vet was an ordeal, for which I prepared by putting on a pair of work gloves. The only person (or animal) she spared was Margaret, whom she adored. Even so, Kit Kat still thought of herself as master (or mistress) over all she surveyed, the Lady Macbeth of cats.

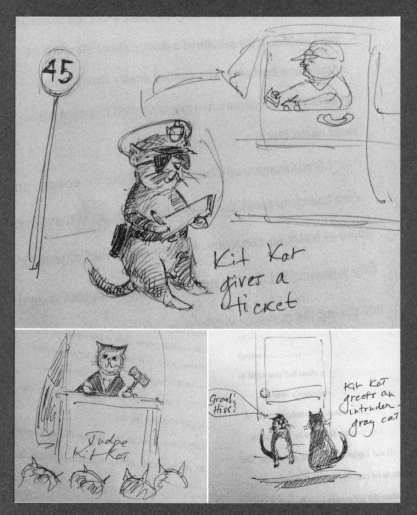

Kit Kat ready for oils

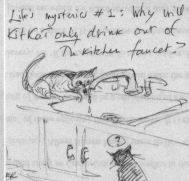

Life's mysteries # 1: Why will Kit Kat only drink out of *the kitchen faucet?*

WATER

WATER

Nurse Kit Kat

Kit Kat gets her fur blonded and high-lighted

Kit Kat at the vet's (in her dreams)

The vet approaches Kit Kat

Kit Kat tries Hibachi shrimp, with chopsticks

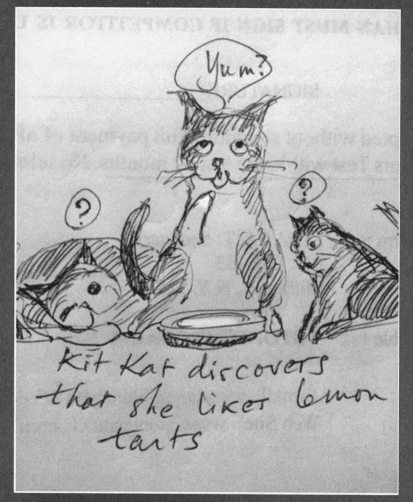

74 Catnip

Ruby taxes up Karate

KAT KARATE

ROUND 1

KAT-ARE

Kayakat

Logan go Bragh (whose sire was Erin go Bragh, the famous combined training champion and star of the *The Little Horse That Could*) was Margaret's competition horse, who went lame after winning #1 at Fitch's Corner, and needed a full year of medical care, and the constant loving attention of Miguel, our barn manager, before the vet passed him fit to ride again, a day of celebration for everybody, including the cats, calling for a glass of champagne.

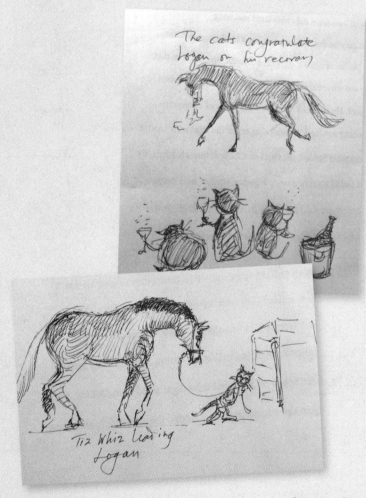

The cats congratulate Logan on his recovery

Tiz Whiz leading Logan

The cats take up tennis

CAT TRIPLE CROWN RUBY

CAT FOOTBALL
RUBY plays GOAL

soccer practice
Ruby heads a goal!

the cats go fishing
for dinner

Ruby's
monster

ozzy

little-known facts—domestic
cats are descended from
saber-tooth tigers.

Fall

Kit Kat as
a school guard

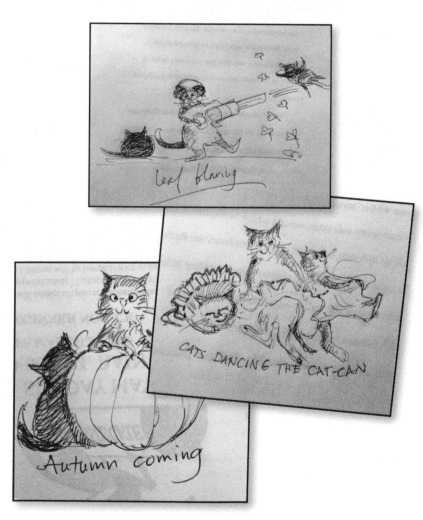

Leaf blowing

CATS DANCING THE CAT-CAN

Autumn coming

Wheee!

Cats on the roller coaster at the fair

TICKETS

The cats go to the Fair.

ICE CREAM

At the Fair

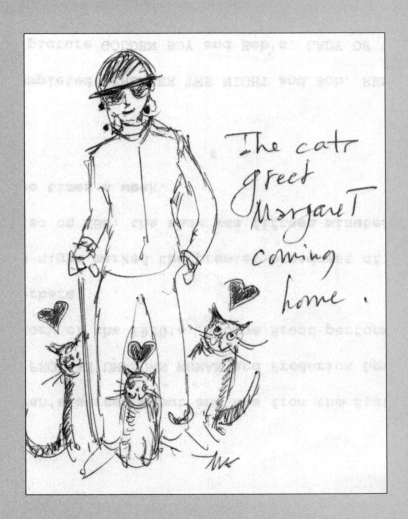

The cats
greet
Margaret
coming
home.

This drawing celebrates Margaret's return home after her first brain surgery and rehabilitation therapy—a happy moment for her, and for the cats. A cat's face smiles naturally, but I think they had big smiles when she came home, and I know she did. Cats are not noisy, like dogs, but somehow they communicate love all the same, the gentle rub against the leg, the throaty purr, the longing look that tells you, "Welcome home, we love you." All of that and more is reflected in this drawing.

And sometimes, when I see Tiz Whiz looking out the tack room window expectantly in the morning, I wonder if she thinks, "When is Margaret coming back?" I think so. Love is not only what we give animals, it is what they give back, in their own way.

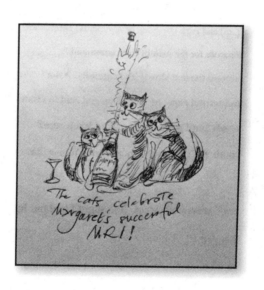

The cats celebrate
Margaret's successful
MRI!

The Cats
delivering
a pizza
for
Margaret

Tiz Whiz meets a bear

Peyton's halloween elephant
mask maker her a new friend.

CATS READY FOR TRICK
OR TREATING

The cats say hello to a deer

Country Cats
Eating Donuts

Tiz Whiz skates
home.

Every morning Margaret and I would have coffee in the tack room with our barn crew, a pleasant part of our routine. The coffee came from Dunkin' Donuts in Pleasant Valley, together with their trademark donuts. One day, to Margaret's delight, Tiz Whiz got hold of one, batting it as though it were a mouse before taking a bite. For Margaret, I drew all sorts of silliness for the cats involving Dunkin' Donuts, from waiting in line to applying for employment. I drew Tiz Whiz roller-skating home with our order; Ruby filming a commercial, donut held in the air like a trophy; and any number of other scenarios that I thought would amuse her.

The cats' table at the Pleasant Valley Dunkin Donuts

Tiz Whiz tries her first donut

the cats go shopping at Dunkin' Donuts

cats in the line
at Dunkin' Donuts

Ruby at the
Dunkin Donuts

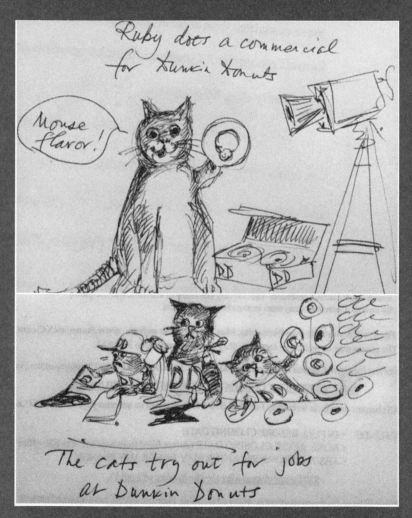

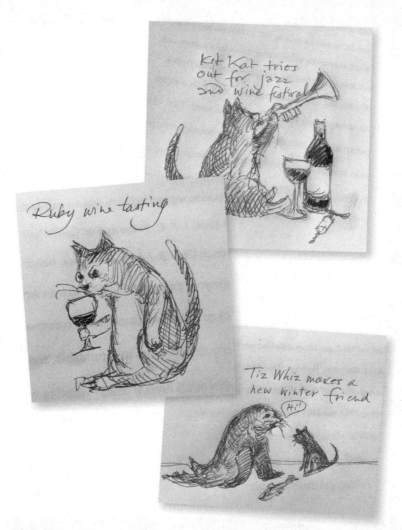

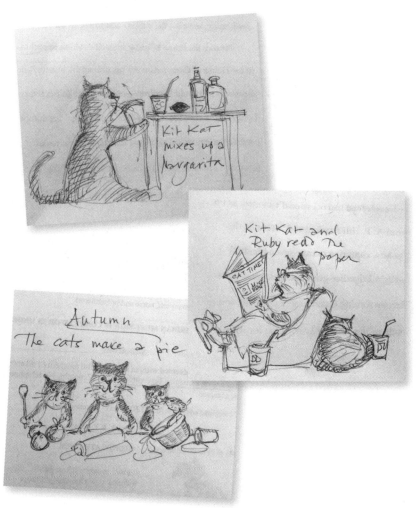

BAD WEATHER
DAY FOR CATS

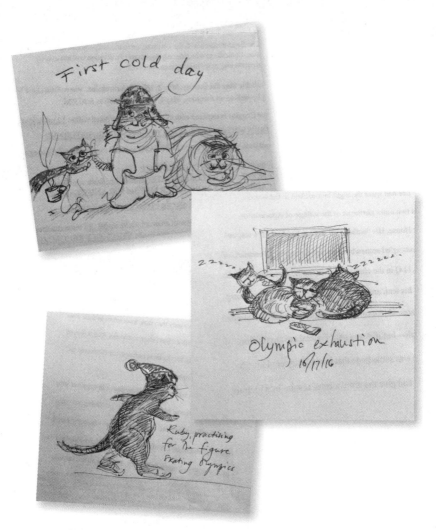

Kit kar reading
the morning paper

Margaret's birthday was November 1st, and she always got presents from the cats. Well, I bought them, but the cards always read "From the cats." In the tack room, we sometimes shared a bottle of champagne with Miguel and the barn workers and whoever was riding that day, and Tiz Whiz would lie down with her head on Margaret's leg, waiting for a lick of cream cheese.

Once Margaret's illness took hold, she no longer wanted to go out to dinner at all, let alone to celebrate, and I'd try to get her something she really liked, Scottish smoked salmon sliced paper-thin, for example, and Kit Kat would sit down and accept a few tiny morsels as her part of the celebration.

They never really gave her flowers, but if they could have they would.

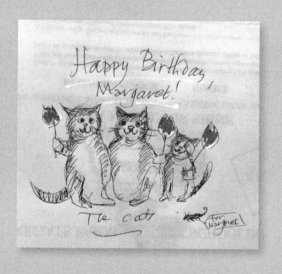

The cats ready to take step one
in preparing Thanksgiving dinner

The cats rethink Thanksgiving menu

ready to go on Thursday!

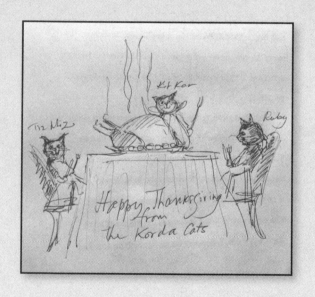

Winter

More snow than expected!
12/17/16

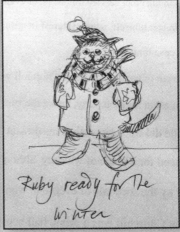

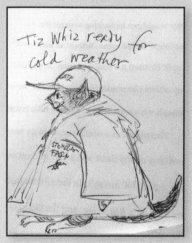

Tiz Whiz rexty for cold weather

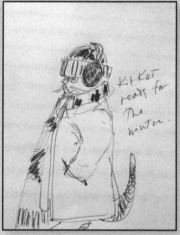

Kit Kat reads for the winter.

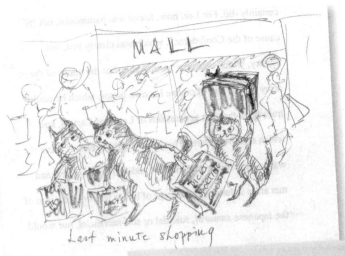

Last minute shopping

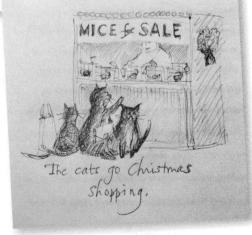

The cats go Christmas shopping.

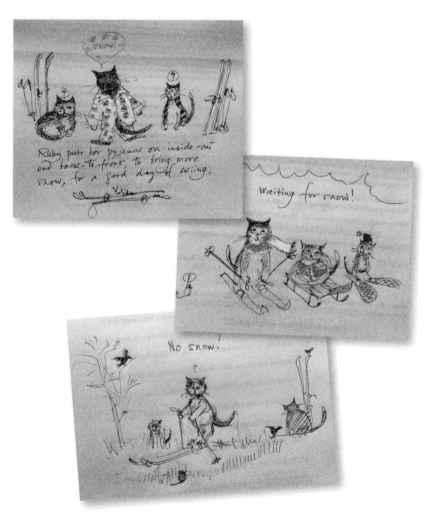

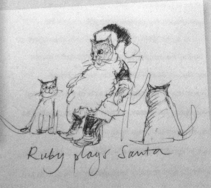

Ruby plays Santa

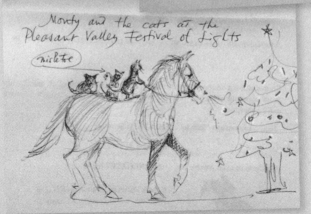

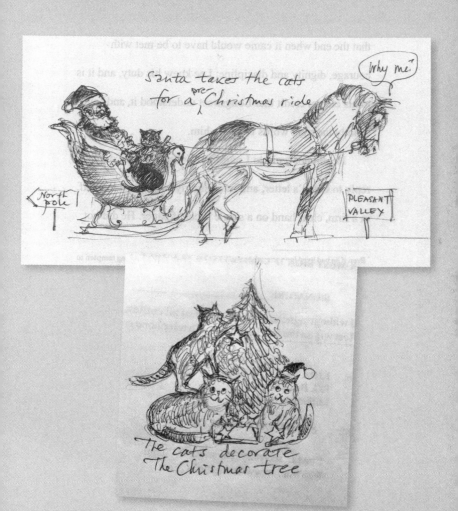

In real life, of course, cats do not celebrate holidays (unless they have a secret one of their own, Cat Day, with a mouse pudding), but ours were always present for the major ones. Kit Kat loved sitting next to Margaret in the TV room while we shared our Christmas treat to each other, a can of caviar from Kelley's Katch in Tennessee (not such huge indulgence, it's paddlefish caviar, but delicious with a squeeze of lemon and a smidge of sour cream and some warm blinis), while George loved to rummage among the wrappings, paper and ribbons on Christmas morning.

The cats were, as a rule, happy when we were happy, sad when we were not, and so they enjoyed holidays in their own way. New Year's Day we always slept late (the horses were off) and the cats loved that too. There's nothing cats like better than sleeping late sprawled out on the bed. They would do it every day if they could.

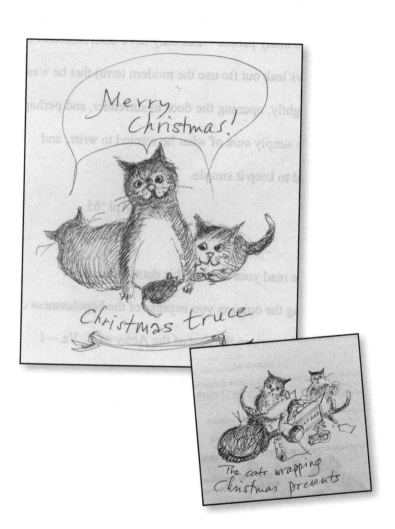

Merry Christmas!

Christmas truce

The cats wrapping Christmas presents

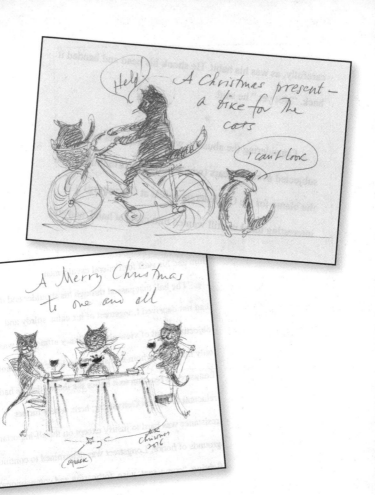

"Boxing Day"

The day after Christmas

TWEET

Happy New Year from
The cats

Ruby Tries to Diet

FIRST DAY OF RUBY'S DIET

Ruby's problem is putting on too much weight. It's not that she eats too much, she has a precise mix of dried cat food and snacks on it throughout the day rather than eating two meals a day, but her exercise level is zero. During the day she lies in the linen cupboard, or in Margaret's closet. If a stranger comes in—or if she hears a vacuum cleaner—she goes under the bed, at night she sleeps on the bed; until exactly six in the morning, when her habit is to wake me up by licking my hair. That is not really an adequate fitness program, but unlike dogs, there is no practical way to exercise a cat.

Ruby exucising

Ruby's New Year Resolution
#1 — more exercise

Ruby working on her abs

exercise time

Ruby does her yoga.

Ruby doing her yoga

Cat yoga

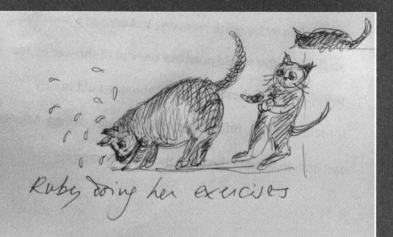

Ruby doing her exercises

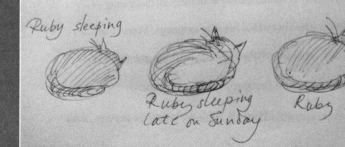

Ruby sleeping

Ruby sleeping
late on Sunday

Ruby awake

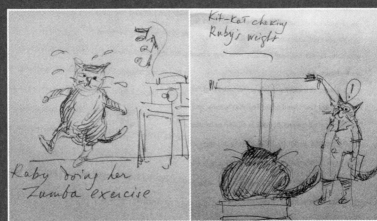

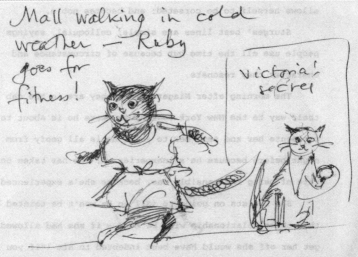

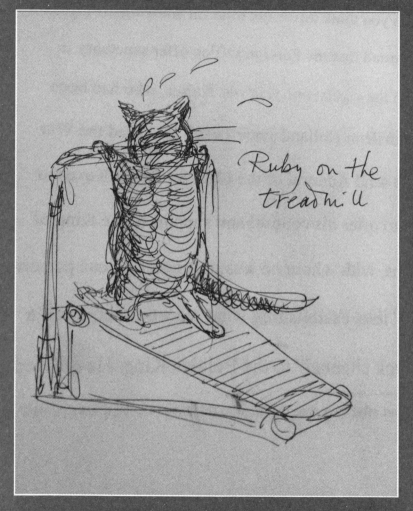

Ruby on the
treadmill

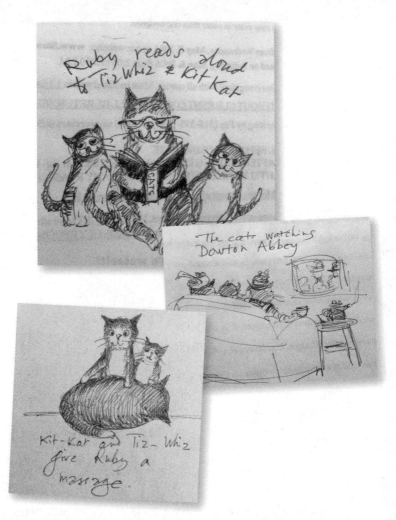

Ruby reads aloud to Tiz Whiz & Kit Kat

The cats watching Downton Abbey

Kit-Kat and Tiz-Whiz give Ruby a massage.

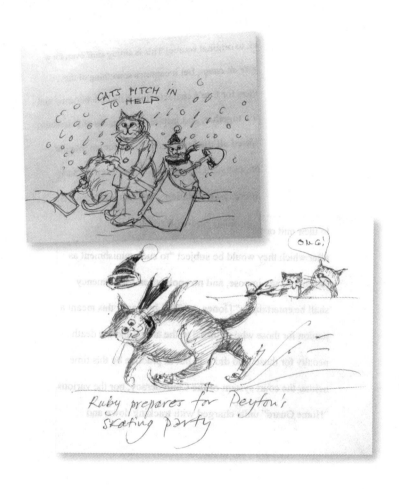

CATS PITCH IN TO HELP

OMG!

Ruby prepares for Peyton's skating party

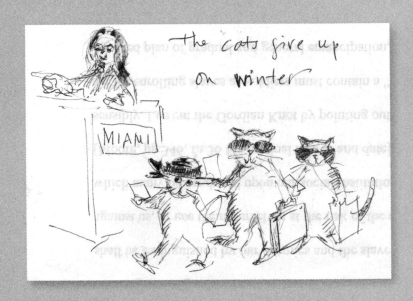

Traveling south to escape the winter is something we projected on the cats. We wanted to escape winter, so it was natural to imagine they did too, but cats, the indoors-outdoors ones anyway, are in fact pretty indifferent to cold weather. Their fur fluffs up, their tails become bushy, yet they go on with whatever it is they have in mind, at temperatures that turn my toes and fingers numb.

Margaret, when I first met her, owned Irving, whom she took to Mexico every winter. The cats which followed him were homebodies, or perhaps Margaret simply decided that she didn't want to put me through the trouble of flying with a litter tray, litter and cat food (that might have been one of the reasons her first marriage came to an end).

In these drawings, the cats reflect my feelings about winter and my feeling that the best way to spend it is on a warm beach somewhere with a daiquiri in my hand. As for Margaret, she was an unapologetic sun-worshipper, whose idea of bliss was lying in the sun in her bikini, so the idea of cats on a beach was amusingly fitting for her.

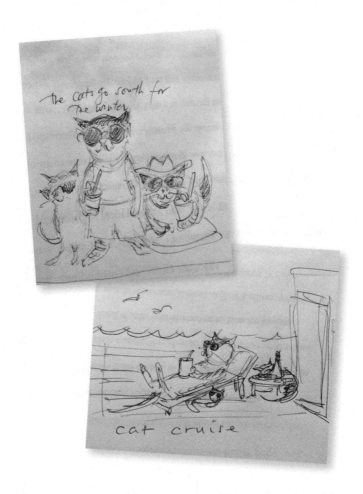

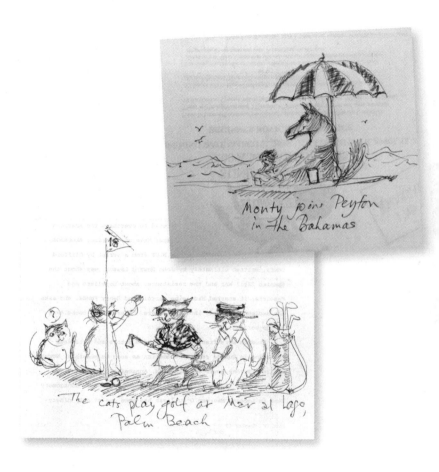

Monty joins Peyton
in the Bahamas

The cats play golf at Mar al Lago,
Palm Beach

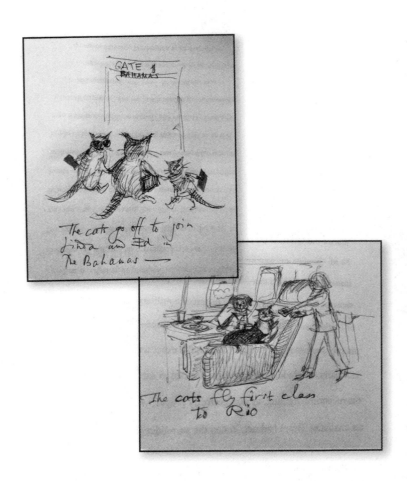

GATE 1
~~BAHAMAS~~

The cats go off to join
Linda and Ed in
The Bahamas →

The cats fly first class
to Rio

146 Catnip

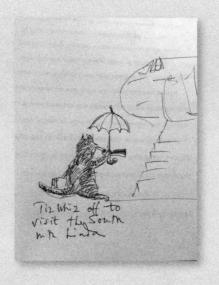

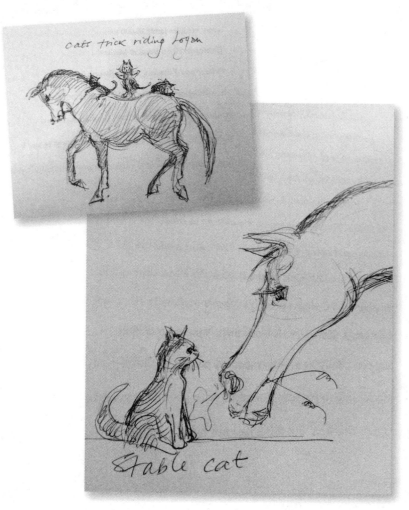

cats trick riding team

stable cat

Hear no evil, see no evil, speak no evil

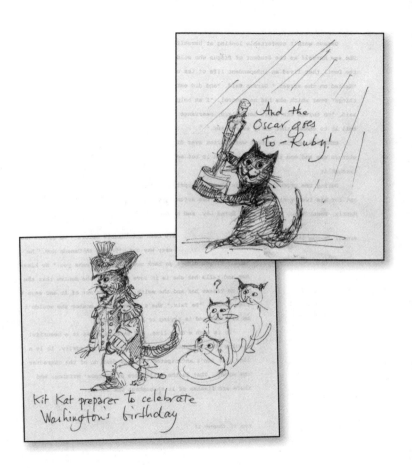

And the Oscar goes to - Ruby!

Kit Kat preparer to celebrate Washington's birthday

Spring

Cat ballet
temprature 50°—
Ruby does her
Spring dance

Today, the barn, tomorrow, the house!

GREETINGS TO THE NEW BARN CAT!

I imagined Margaret in her riding clothes taking the cats for a walk. Well, as everybody knows, putting a cat on a leash would be an exercise in frustration. Cats aren't going to be led anywhere, they go where they want to go, at their own pace. When Margaret had pigs (four of them), she would take them for walks, but they didn't like leashes either, so she would dropped marshmallows behind her and they followed. But I don't think cats are greedy enough to follow anyone, not ours anyway.

CATS LEARNING TO COOK

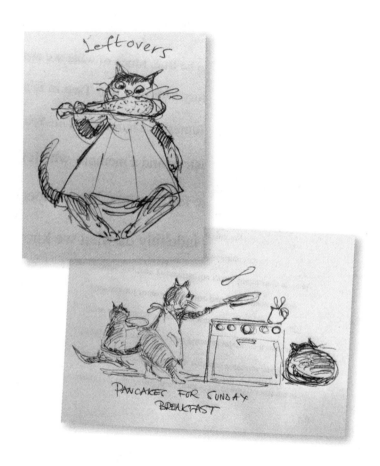

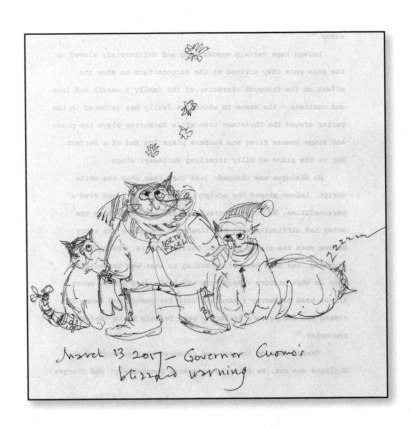

March 13 2017 — Governor Cuomo's
blizzard warning

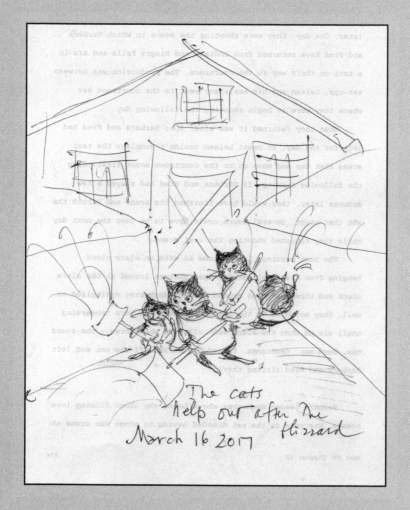

The cats
help out after the
March 16 2017 Blizzard

For many of the years during which Tiz Whiz occupied the tack room in our barn, getting on for more than ten now, it was always a trial to get her to eat. To Margaret's despair, since she likes her animals well fed and plump, Tiz Whiz merely sniffed at cat food, and even on the rare occasions when she agreed to try it, she might turn down the same brand or flavor the next day.

We tried scraps from our own table, without much success—she would sometimes eat a bit of carne asada from Puerta Azul, a nearby Mexican restaurant, but only if it was rare and without sauce, she rejected food from Tokyo Tavern (we never told the chef/owner that we were ordering shrimp hibachi for a cat), and even a rare steak from Café Les Baux, the excellent French restaurant in Millbrook, did not tempt her much, though she would try the *sôle meunière*.

Then one day during Margaret's illness, Tiz Whiz decided to start eating, as if to please Margaret, and went from very thin to pleasingly plump in no time at all, emptying a can of Fancy Feast twice a day. She does not show any promise of swelling to Ruby's size, but she's no longer waif-like.

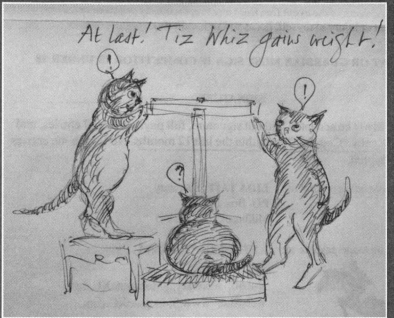

Pleasant Valley
bike day

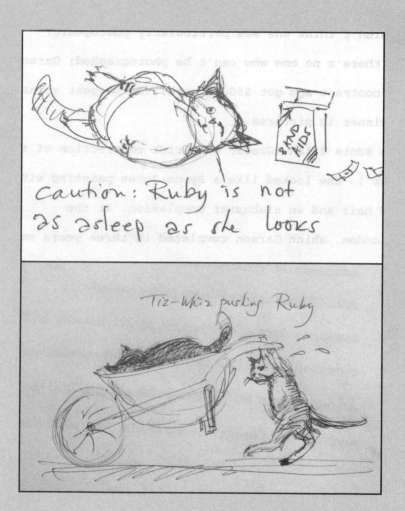

Caution: Ruby is not as asleep as she looks

Tiz-Whiz pushing Ruby

This drawing celebrates the fact that my Lawrence of Arabia biography, *Hero*, was optioned for television. The cats are dressed up as Arabs, and poor Monty is trying to look like a camel. I would have had to get them SAG-AFTRA union cards, but that hadn't occurred to me, or to them. So far, their acting careers haven't gone anywhere, although Ruby is pretty good at pretending that when she throws up on the best carpet that it isn't her fault.

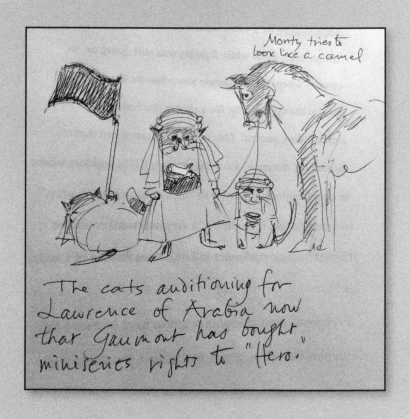

Monty tries to look like a camel

The cats auditioning for Lawrence of Arabia now that Gaumont has bought miniseries rights to "Hero."

"Wellies"

Ruby prepares for her magic act →

Kit Kat prepares for her book club

cow-cat

Ruby prepares to blow out the birthday candles on her cake

Happy birthday, Ruby

The other cats admire Tiz Whiz's new flea collar

— cats waving goodbye
to Margaret —

This was a sad day, when Margaret went back to the hospital for her second brain surgery after the brain tumor reappeared on her MRI. The cats may not have realized what was happening, after all in real life they are cats, not people, but that doesn't mean that they don't pick up the signals of anxiety, fear and regret from the humans around them, and process those signals in their own way. They are also able to recognize that luggage being packed into the car means somebody is going away, not just down to the city for a day, but for longer.

They do not like departures. Ruby hid under the bed, Kit Kat displayed unusual affection, Tiz Whiz burrowed down among the saddle pads; somehow they knew. If they could have waved goodbye or cried, they would have.

flying
squirrel

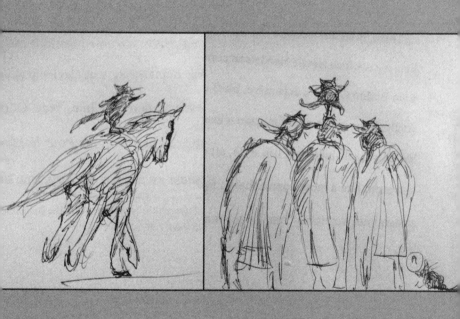

Margaret Korda

1937–2017